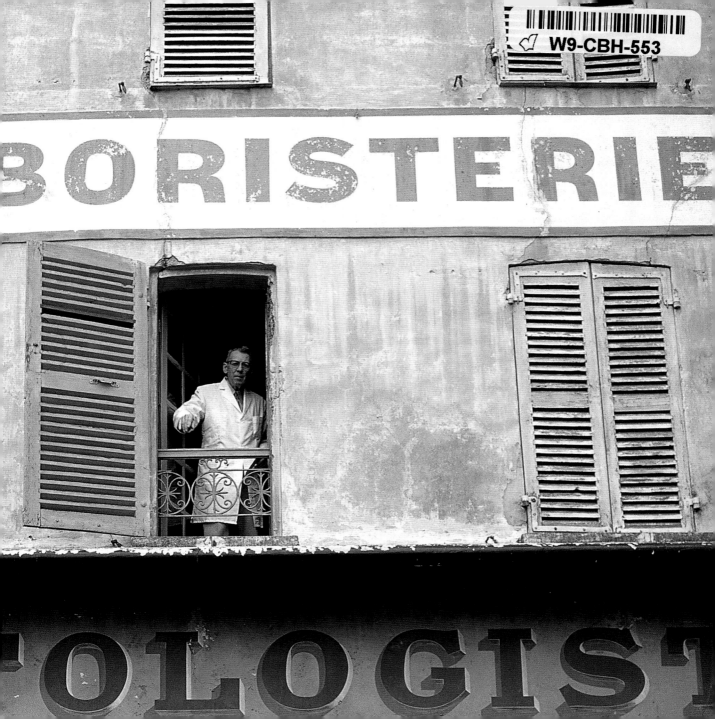

ENTREZ

SIGNS OF FRANCE

PHOTOGRAPHS BY **STEVEN ROTHFELD**

TEXT BY **ANDRÉ ACIMAN**

ARTISAN · NEW YORK

PUBLISHED BY ARTISAN
A DIVISION OF WORKMAN PUBLISHING, INC.
708 BROADWAY
NEW YORK, NEW YORK 10003-9555
WWW.WORKMAN.COM

LIBRARY OF CONGRESS CATALOGING-IN-PUBLICATION DATA

ROTHFELD, STEVEN.
 ENTREZ : SIGNS OF FRANCE / PHOTOGRAPHS BY STEVEN ROTHFELD ;
TEXT BY ANDRÉ ACIMAN.—1ST ED.
 P. CM.
 ISBN 1-57965-170-4
 1. DOORWAYS—FRANCE—PICTORIAL WORKS. 2. SIGNS AND
SIGNBOARDS—FRANCE—PICTORIAL WORKS. 3. DECORATION AND
ORNAMENT, ARCHITECTURAL—FRANCE. I. ACIMAN, ANDRÉ. II. TITLE.

NA3010 .R68 2001
729'.19'0944—DC21 00-065049

PRINTED IN SINGAPORE
10 9 8 7 6 5 4 3 2 1

DESIGN BY PAUL HANSON AND ELIZABETH JOHNSBOEN

PAGE 1: HERBORISTERIE, ANTIBES
PAGES 2–3: PHILLIPPE, TARASCON
PAGES 4–5: CHAPELLERIE, ANNECY
PAGES 6–7: PLAGE, NICE

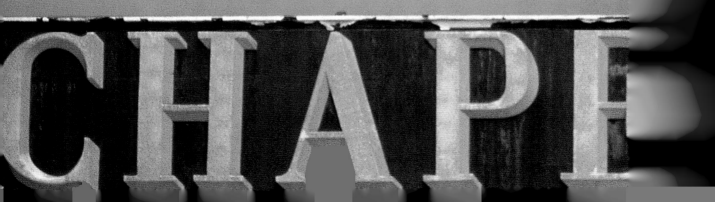

CONTENTS

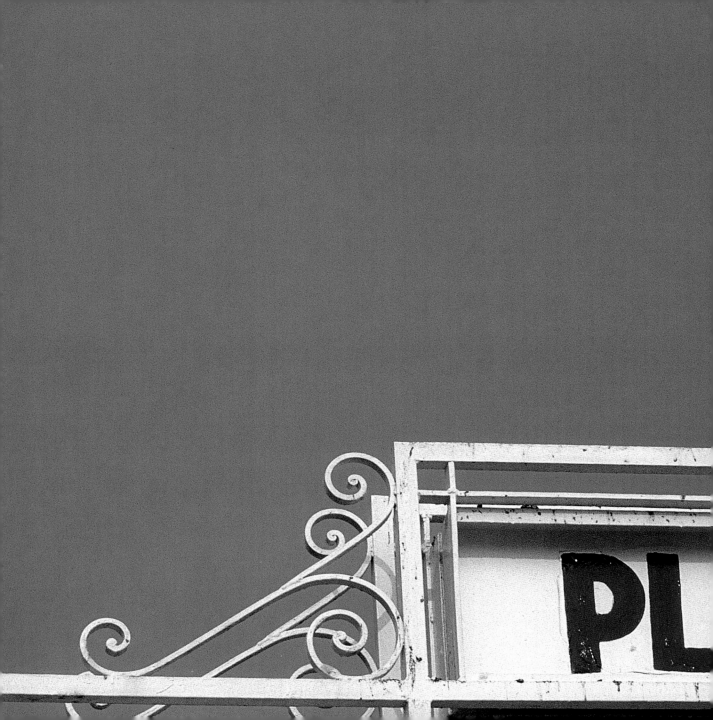

For lovers of the sea,

this is not just the entrance to the beach,

but to something as airy and impalpable as ciel,

meaning "sky," and—yes—heaven.

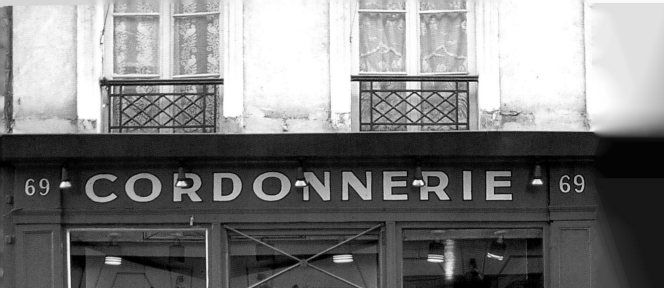

The image seems frozen in time. The ancient wares, the old sheer lace, the vintage *deux chevaux* automobile, the window upstairs ever so discreetly left ajar, the timeworn shop you wouldn't think of owning nowadays unless you were too old to sell, or too settled to let go of, or too lucky to inherit—everything seems Old World.

The hodgepodge of goods and wares piled in a shop almost arbitrarily called *cordonnerie* seems definitely Old World, because if there is one thing that this and every other picture here conveys, whether it is of a sign reading *papeterie, bistro, droguerie, quincaillerie,* or *mercerie,* it is the sense that time is not of the essence here, that things can and will grow very, very old without expiring, that shop windows could easily outlast us here, that time itself can, against all expectations, pull out a last trick and do the one thing it wasn't ever meant to do: stop. If these old doors and old store signs beckon and beguile now, it is not because of their sense of timelessness alone, but because they also lead into a world as spellbound and magical as a fairy tale called France.

CORDONNERIE, PARIS

Morning sunlight, the telltale bell that signals a customer. The old shopowner rummages through stacks abandoned generations ago. He'll find what you want if you give him time, he grumbles.

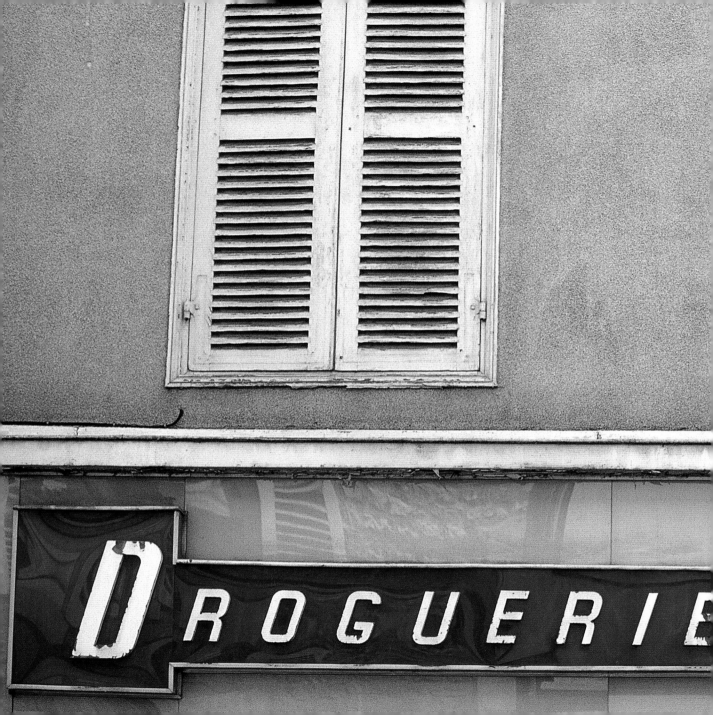

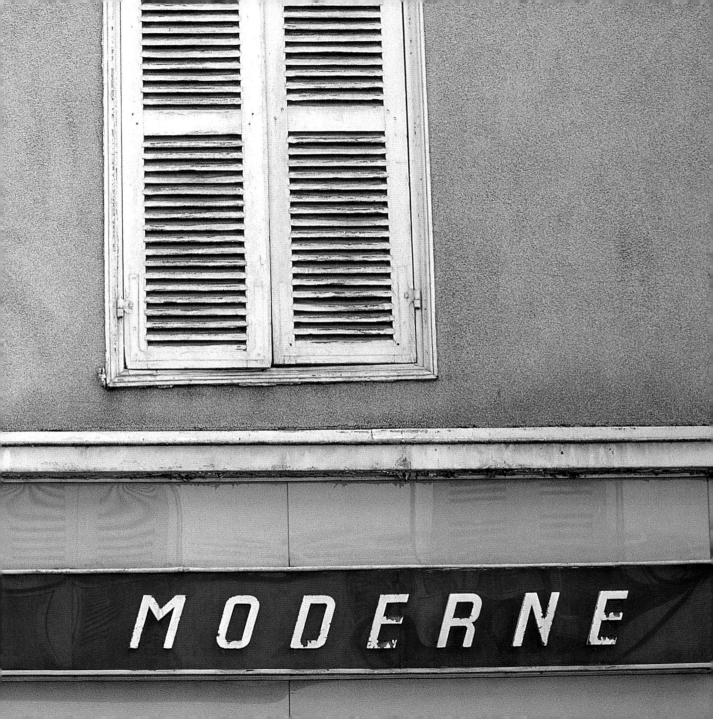

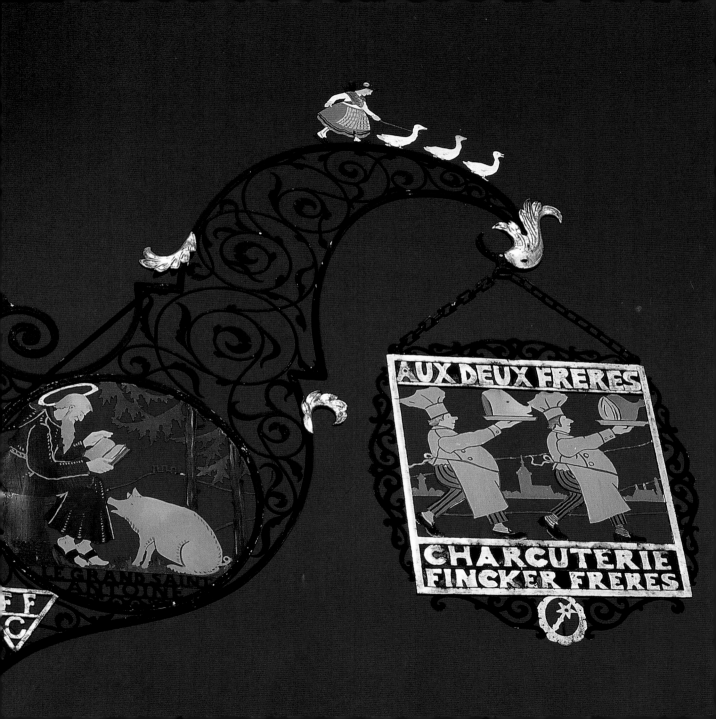

This is the France the French know best and love best, their private France, the one they grow up with and have pictures of and instantly turn the clock to when no one's looking, the France they'd like nothing better than to hand over to their children in the twenty-first century, the way it was just barely handed over to them after two world wars from those who inherited it from the nineteenth century—a France that, for all its turmoil at home and elsewhere, and for all the changes brought on by the Information Age and the Age of Anxiety, has managed to safeguard the daily rhythm and precious rituals of its day-to-day life, a France that always seems to trust it will be there tomorrow, a France that is always open for business and infallibly closes at very set hours. It is a France that, all told, is never bigger than a city block but that, within its narrow purview, easily explains why so many Parisians have never ventured beyond their own *arrondissement* or why so few have ever bothered to learn another language. They know every conceivable shade of the French subjunctive and know every meandering anonymous lane near home—and that's good enough. Walk the block from the *fromagerie* to the *boulangerie*, to the *boucherie*, to the *traiteur*, to the *marchand de tabacs*, to the *fruitier, crémerie,* and *charcuterie,* and, come to think of it, you have walked the world.

CHARCUTERIE, COLMAR

The portly and the pork, that strange kinship between the butcher and his meat, as though by being one you become the other—that touch of whimsy and good cheer in every charcutier, *signifying his cut is kindest.*

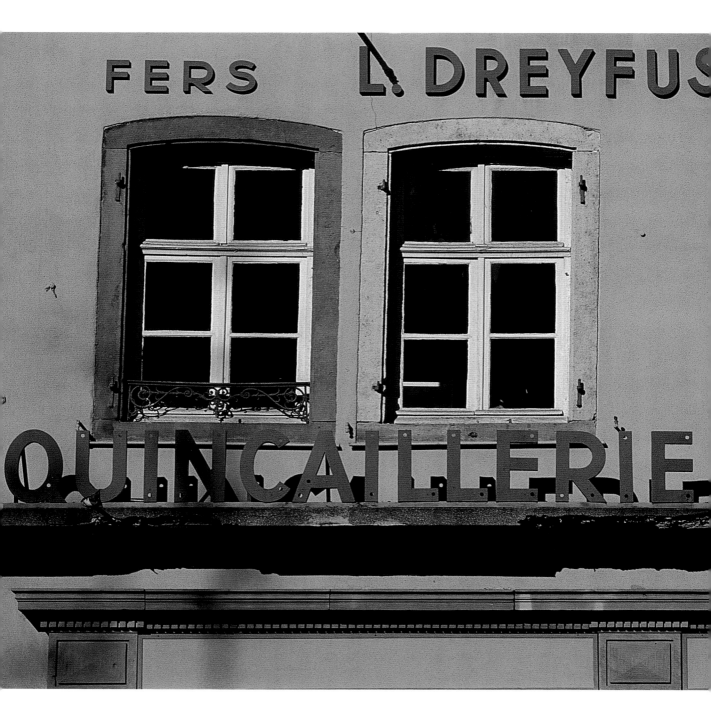

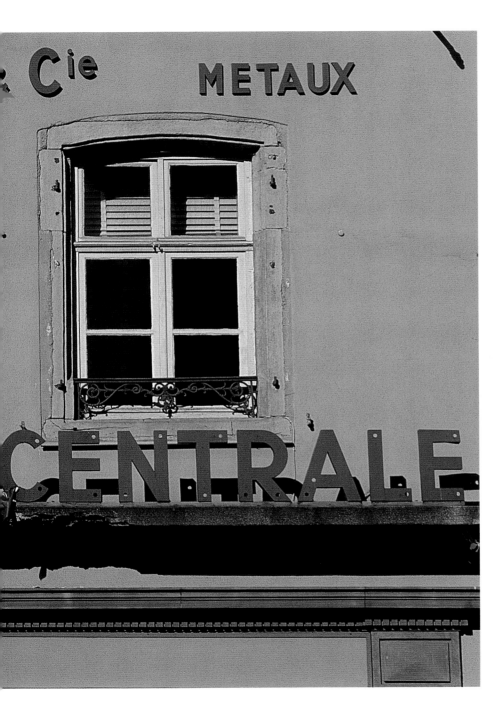

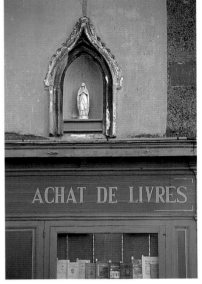

ACHAT DE LIVRES, ST.-MALO

QUINCAILLERIE, SELESTAT

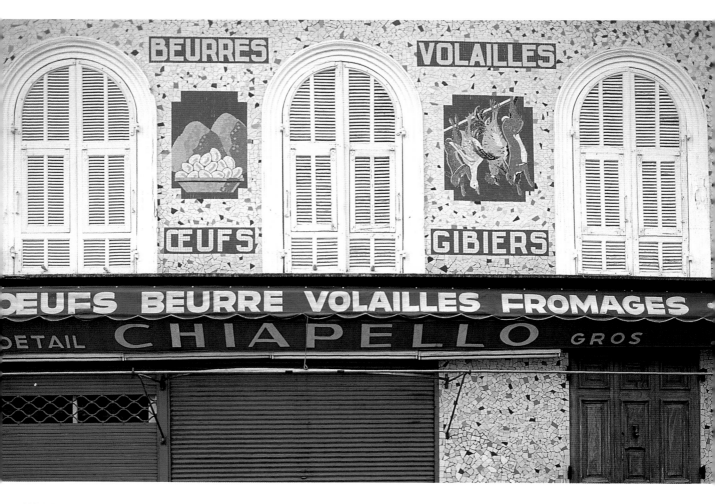

CHIAPELLO, NICE

CONFECTIONS, PONT–AUDEMAR

A world where everything has its place, everything is in order and serene, like the color lilac. Beurres, volailles, oeufs, gibiers and impermeables, fourrures, bonnets, chemises—*words that have as precise a relationship to one another as do elements on the periodic table.*

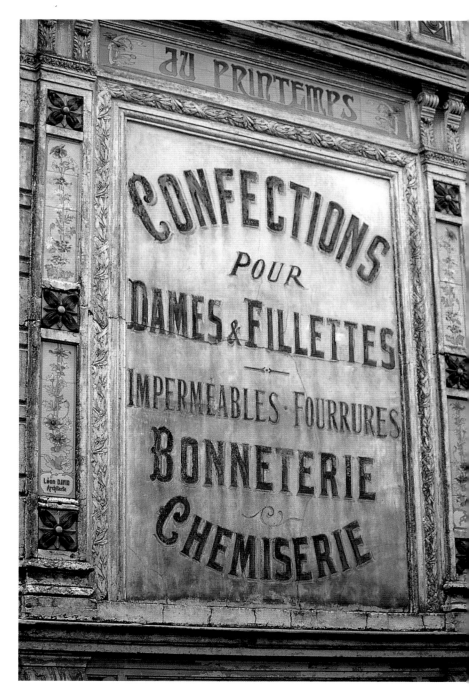

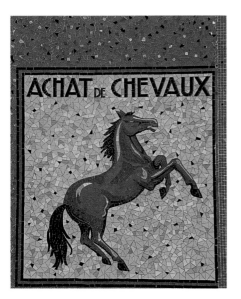

ACHAT DE CHEVAUX, PARIS

AU CHEVAL DU MARAIS, PARIS

At the horse butcher's: there are
those who know which parts
to buy, which to cook how, and
what makes excellent stew.
Does the butcher spot those who
shudder at what he does?

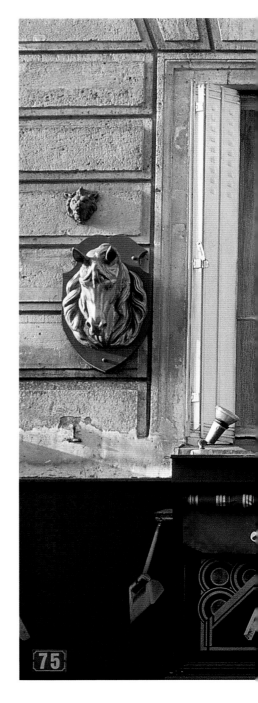

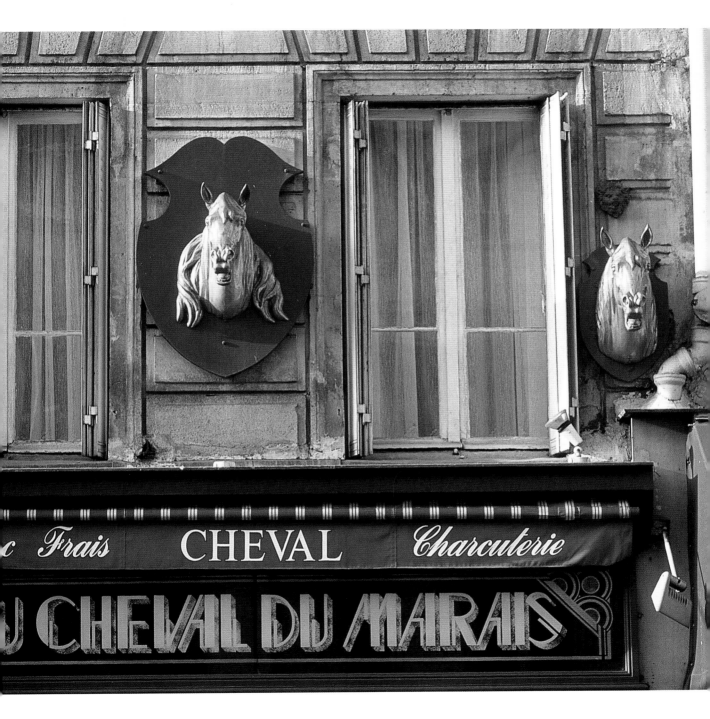

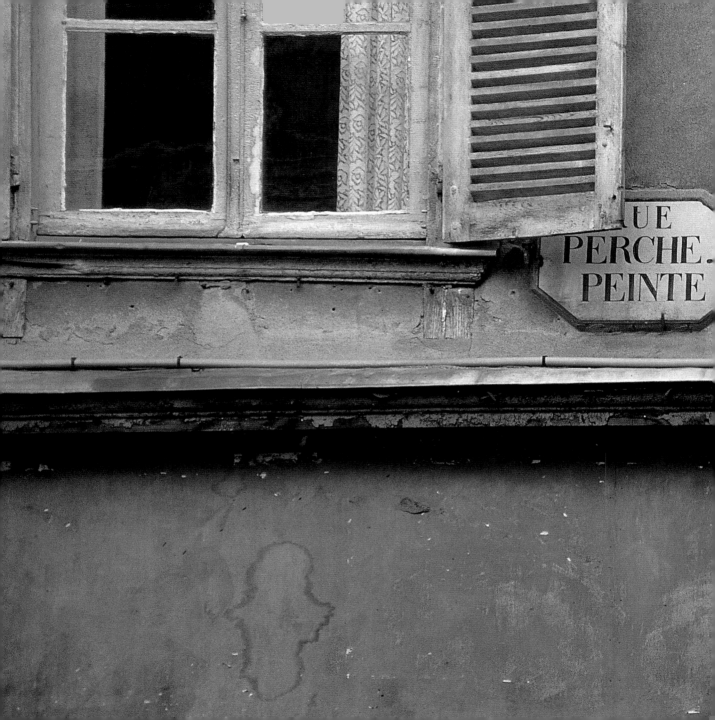

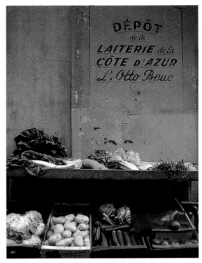

DÉPÔT, NICE

RUE PERCHE PEINT, TOULOUSE

The inimitable musical squeak of

hinges on warm summer afternoons.

The smell of old wood and chipped

enamel paint on old persiennes.

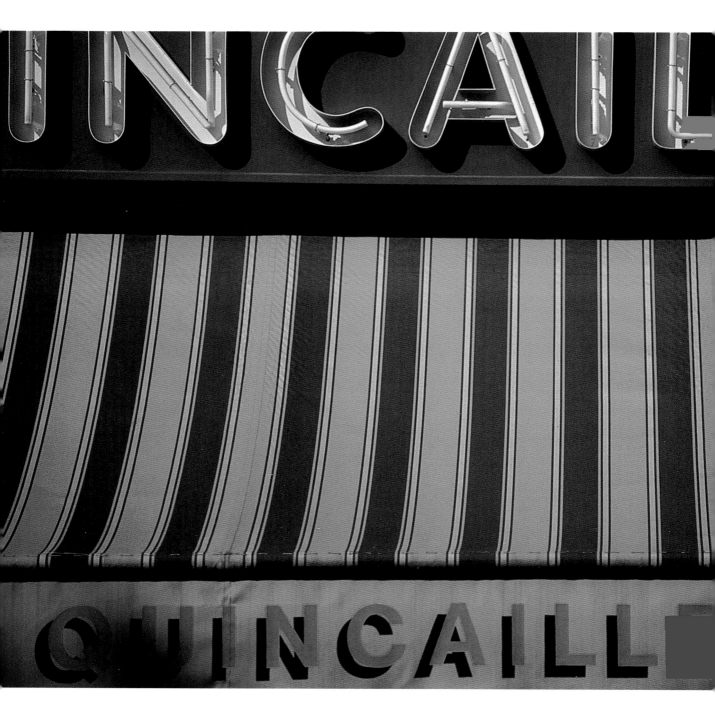

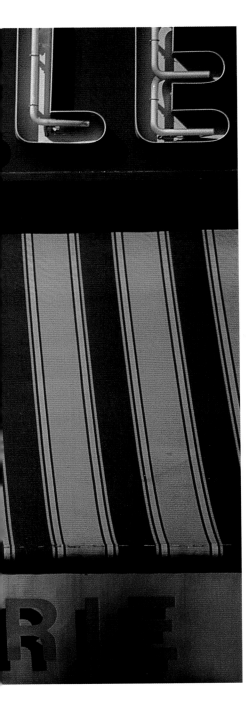

QUINCAILLERIE, LYON

Quincaillerie, *from old French*

quincaille, clincaille, clinquer—

to clank, clatter, clink—French

for "hardware."

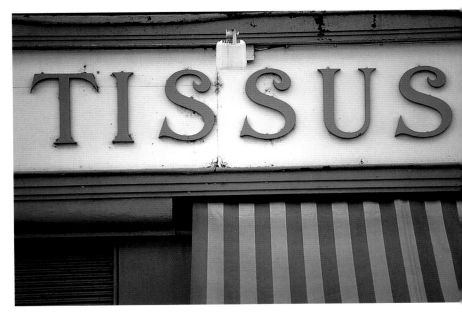

TISSUS, LYON

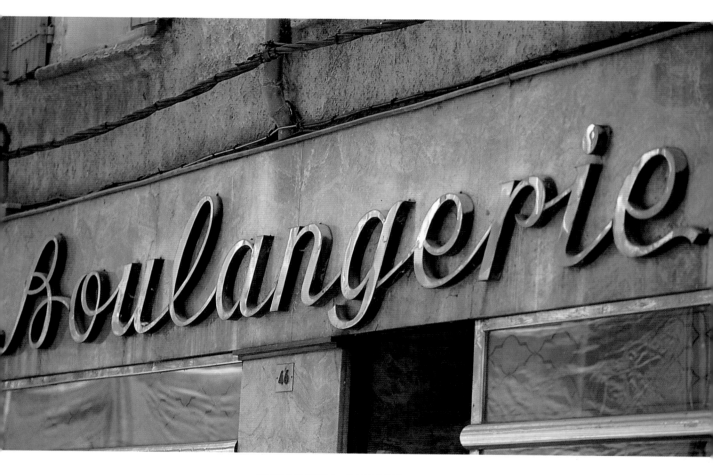

BOULANGERIE, CARPENTRAS

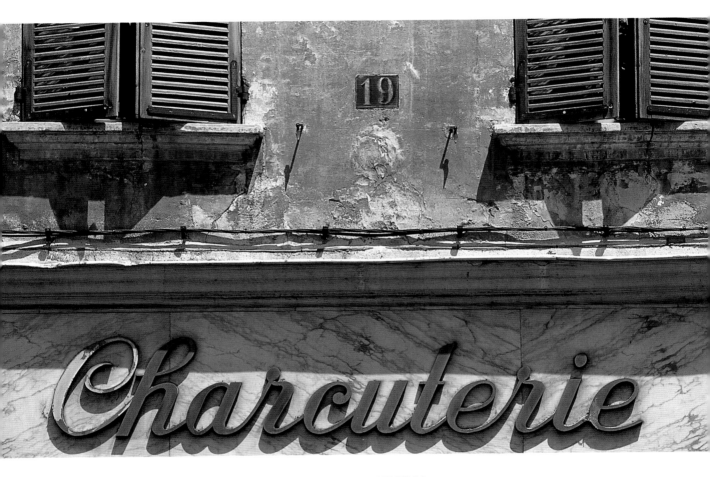

CHARCUTERIE, CARPENTRAS

Smell jambon *and* saucisson *as you*
part the beaded curtain, leading into
the shop, and take your place in line.

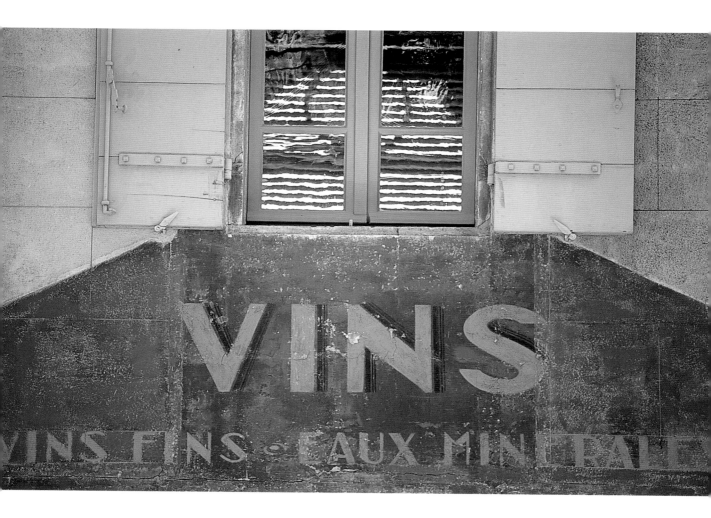

At night, shutters are drawn all the way. Then when the tiniest light is lit within, you can see slatted human shapes hover from room to room, bending down, looking for cigarettes.

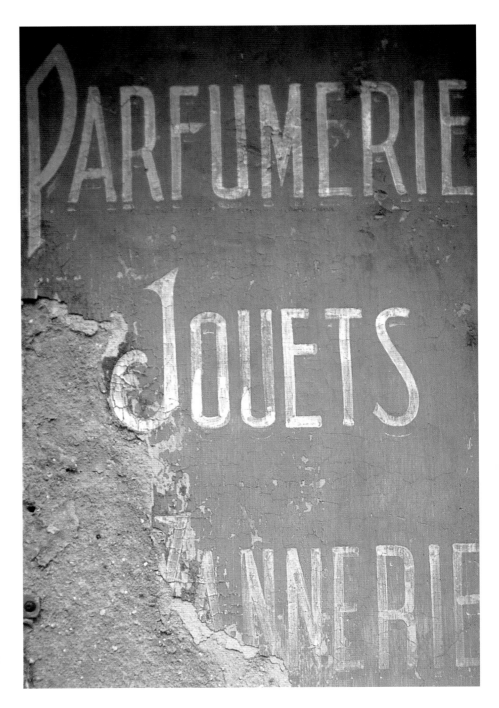

PARFUMERIE, LES MEES

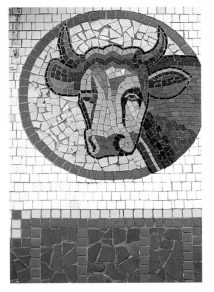

BOUCHERIE, MONS

CHARCUTERIE, CHINON

The sweet, grating sound of the
meat slicer as every charcutier,
this gentleman among butchers,
piles one slice of ham at a time
and chats with customers.

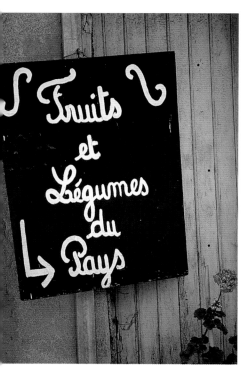

FRUITS ET LÉGUMES,
COUDES, DE FENOUILLEDES

*The handwriting is always
a child's. The curves are always
a bit too stressed, too dutiful,
as though still mindful of writing
exercises.*

BOUDINS FRAIS, ALSACE

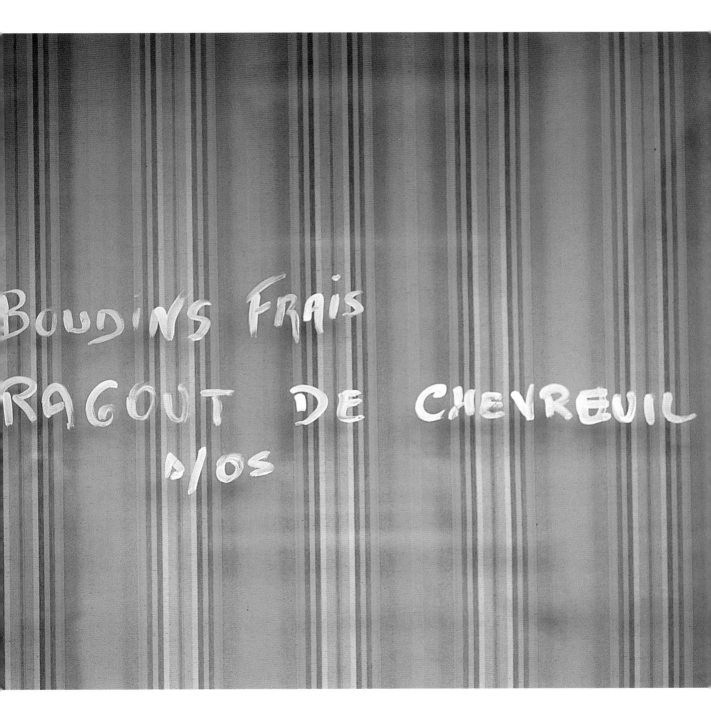

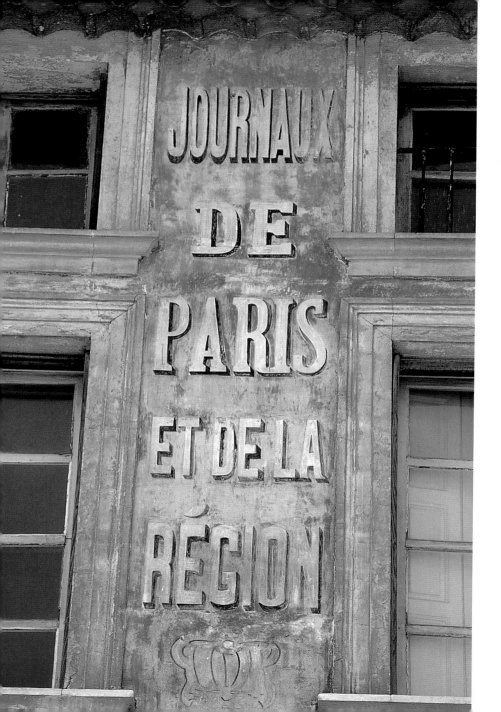

JOURNAUX DE PARIS,
CARPENTRAS

G. MESPLÉ, TOULOUSE

Brazen ebullience of Art Deco block letters—loud, cumbersome, and full of themselves. Elsewhere the rounded grace of the Art Nouveau script, something muted and wary in the way words always call away attention from themselves.

MODES, COTÍGNAC

overleaf

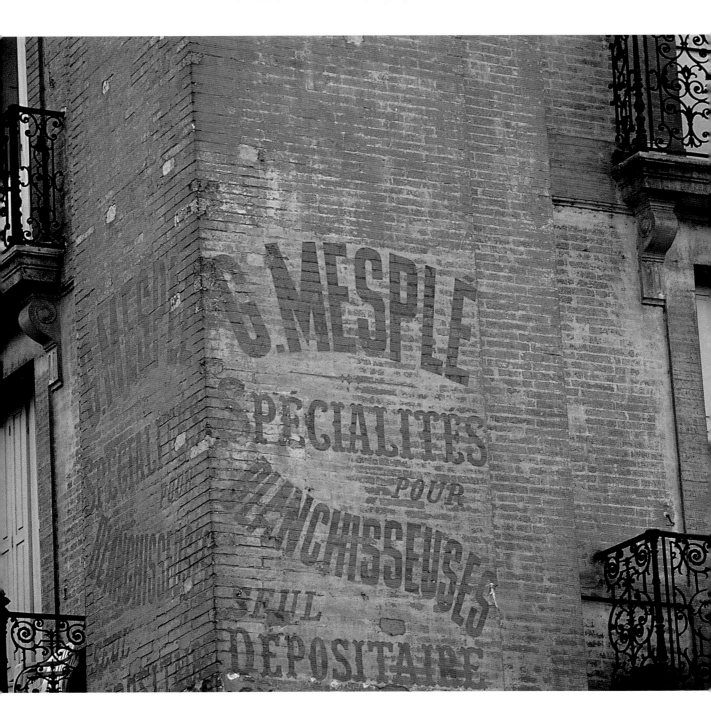

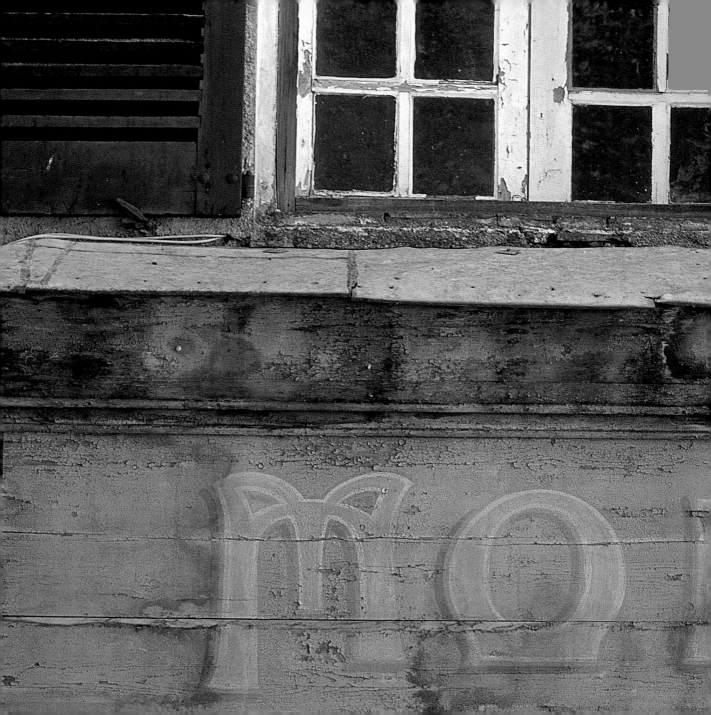

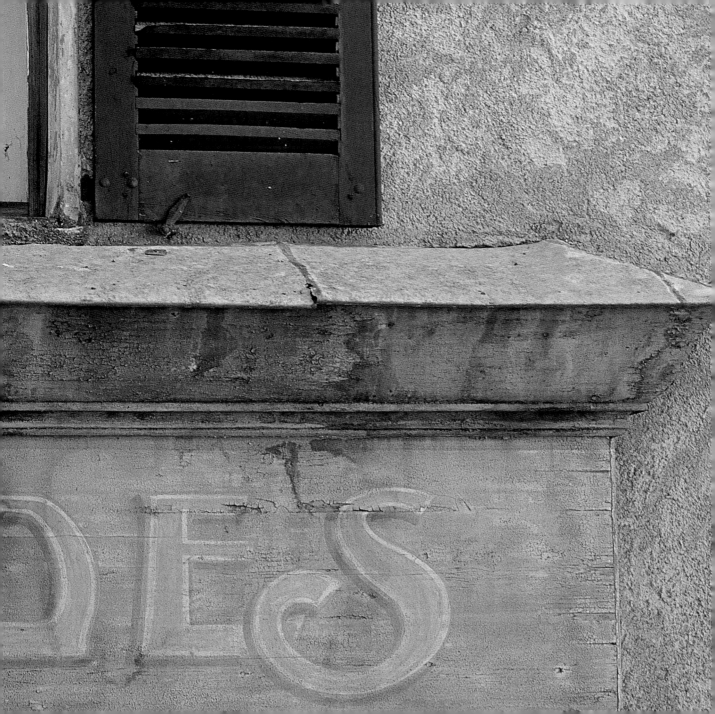

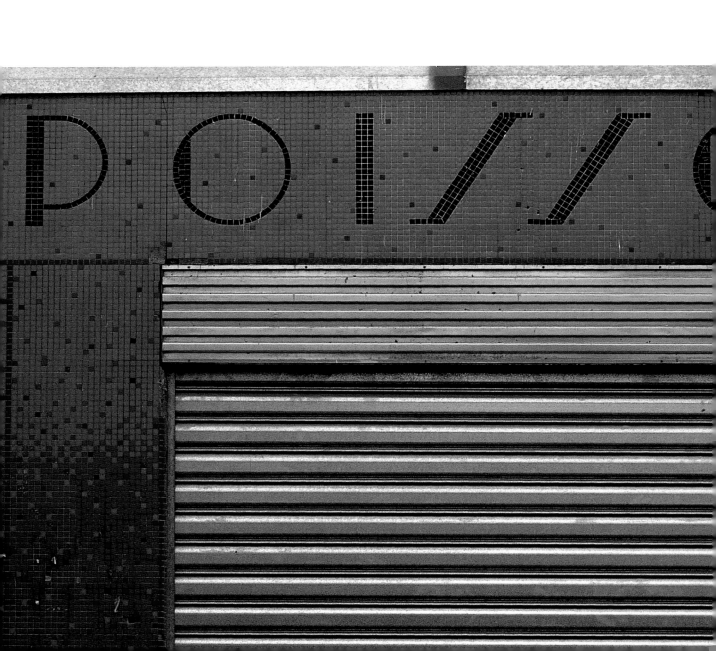

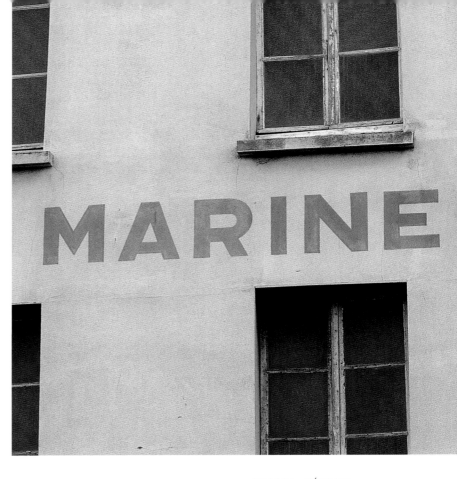

MARINE, FÉCAMP

POISSON, PARIS

*Afternoons are always dark along
the Mediterranean: too much sun,
better stay indoors, there'll be plenty
of time after five to bask in the
sunlight again.*

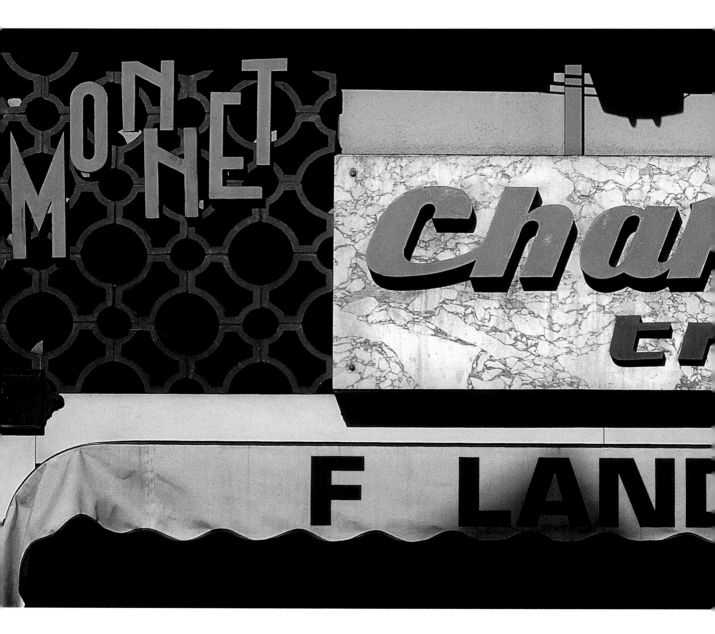

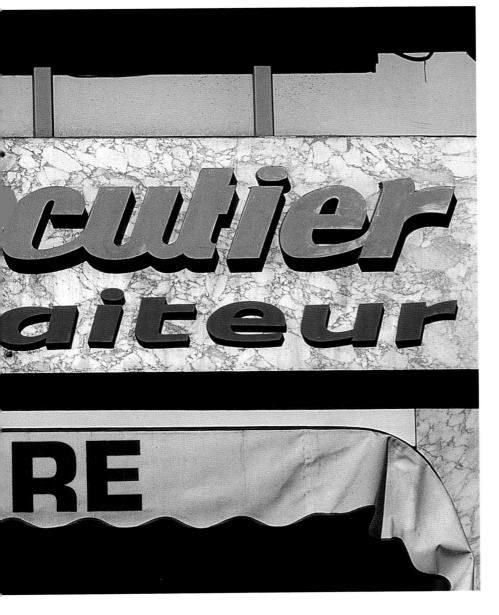

MONNET CHARCUTIER,
BAR-SUR-SÉINE

CRÉMERIE, AUXERRE

Wooden persiennes, *so warm*
to the touch, as human as a
stranger's hand—one doesn't
let go immediately.

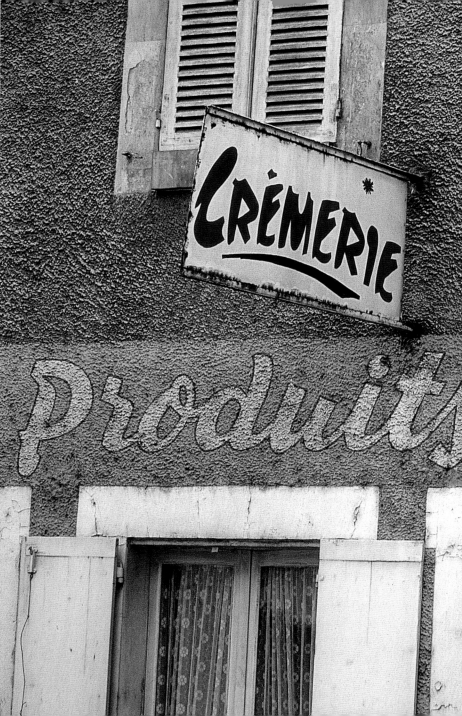

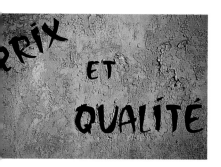

PRIX ET QUALITÉ,
AIGUËS VIVES

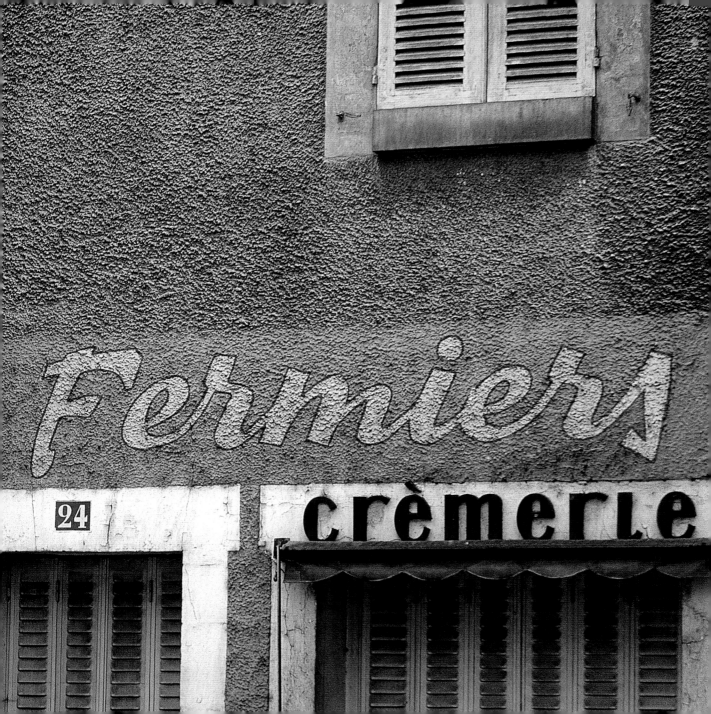

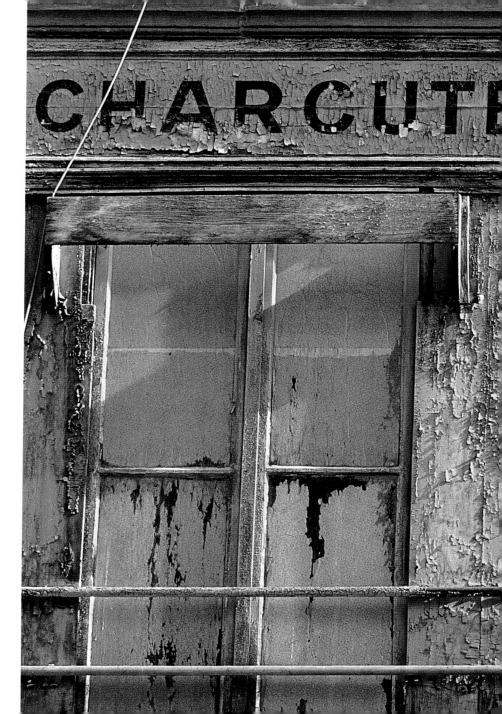

CHARCUTERIE, PARIS

The color ocher, like sunlight

on a field of dandelions,

almost delicious.

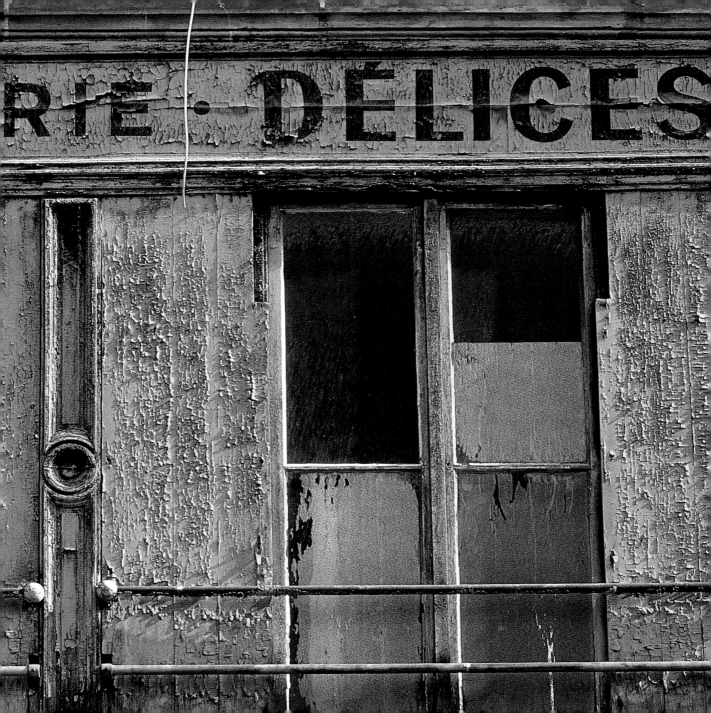

BOULANGERIE, PARIS

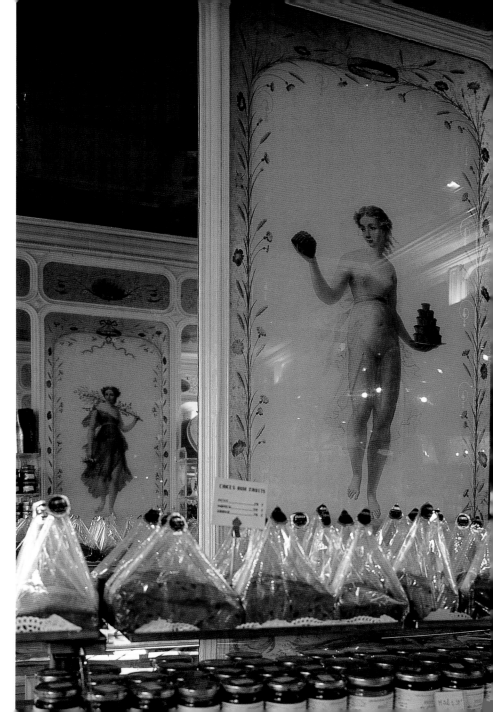

PÂTISSERIE, PARIS

Cellophane pyramids in a valley of cakes—an embarrassment of riches. Someone inspects jams with handwritten labels: coing, mirabelle, figue, groseille, cassis, rhubarbe, *and berries ranging in color from the most regal purple to sallow yellow.*

NOUVEAUTES, BRACÍEUX

overleaf

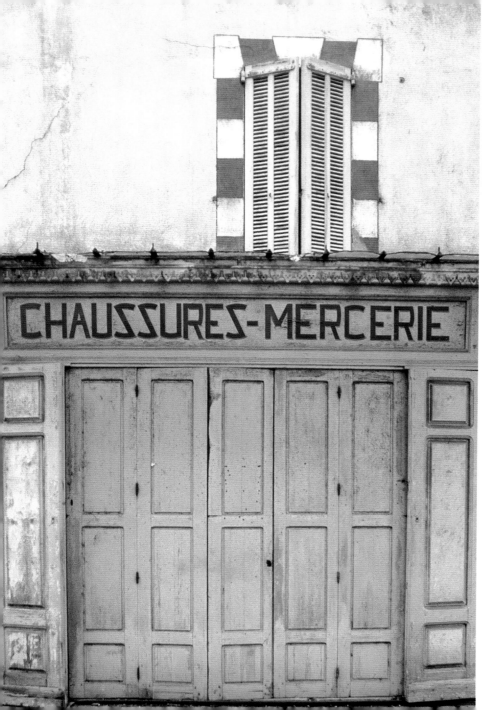

CHAUSSURES-MERCERIE,
LES MEES

*In the afternoon, the persiennes
are almost always half drawn, with
the handle holding both panels in
place in that unmistakable V shape
that allows insiders to look out
without anyone looking in.*

*A thin band of sunlight is cast
across wooden floors and wool
carpets. An air of silence as nowhere
else in the world. The scent of a
rosemary bush. The warble of doves.
Unavoidably, sleep settles in.*

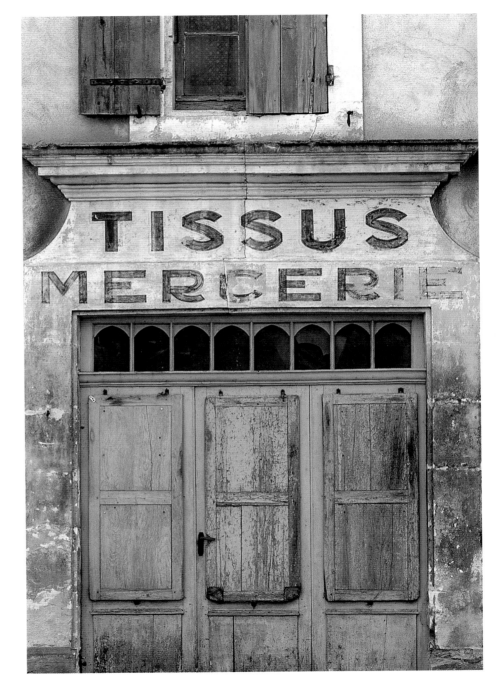

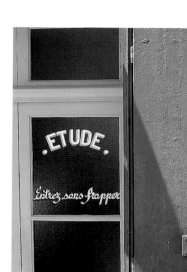

ENTREZ SANS FRAPPER,

ST.-QUENTIN

L'ALIMENTATION, SOUILLAC

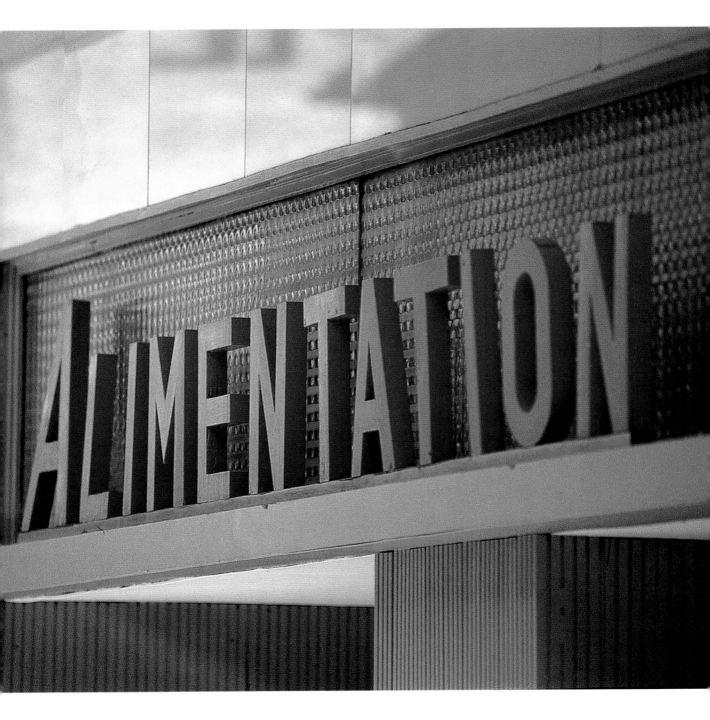

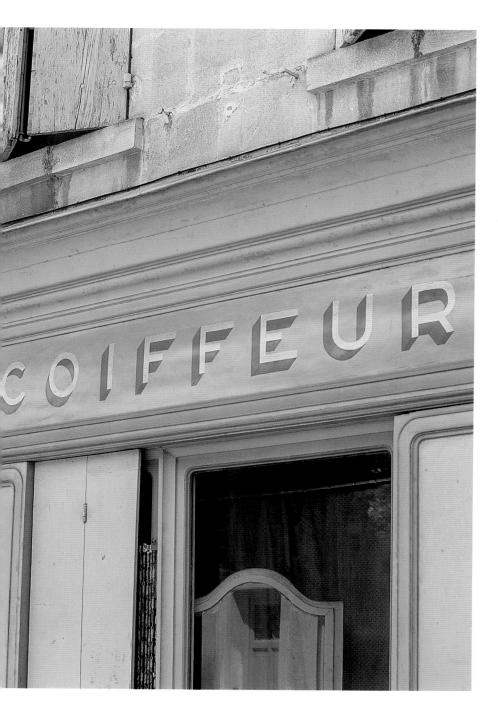

COIFFEUR, ST.-RÉMY

*That magical moment when
shoppers stare through a window
pane and let their eyes wander,
crossing over into yet another
room, finally reaching a window
at the back overlooking a
sunlit landscape.*

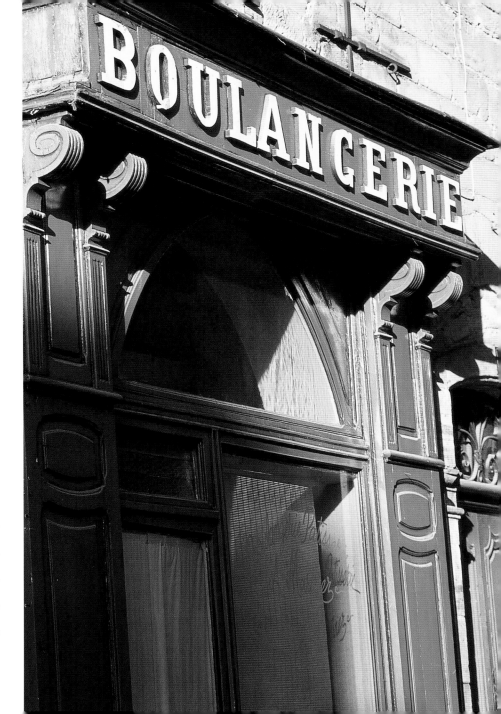

BOULANGERIE, FIGEAC

Or was the landscape merely reflected on the window pane and gazers, eager to stare inside, never realized that what they were admiring was right behind them all along.

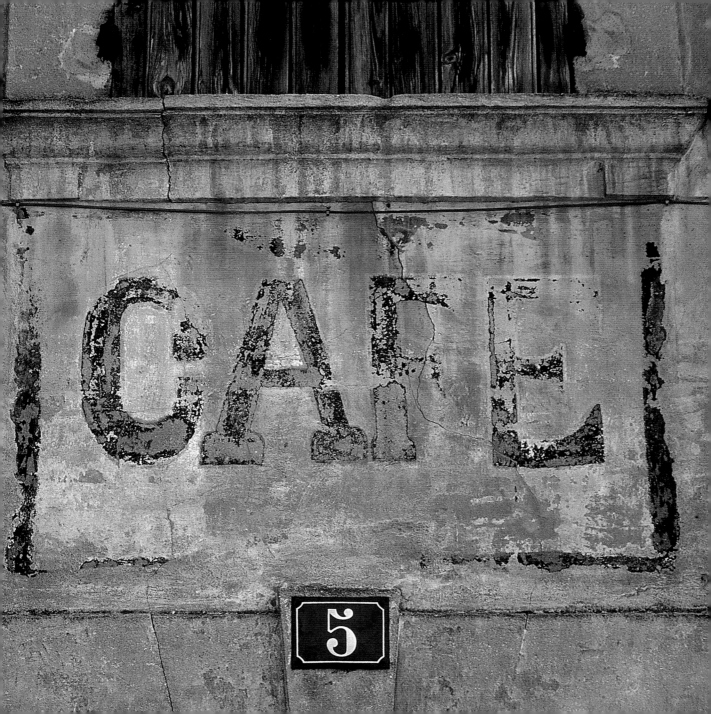

ozy, snug, warm, and secure, a café is not only a second home in a country where homes are always too small, or where being alone is unthinkable; it is a place where one draws closer to others. In *La Bohème*, everyone would sooner go to a cabaret than stay at home, for one is more comfortable out than in. Homes are cold. Bistros are warm. Food is reliably good, cheap wines are still good to drink, and when they're not, they'll go down well enough in good company, which is always, always good. Cafés may occupy street corners and open up to the world, but they also fend off the world a while—for one tends to be more personal in public than in private, and people are closer in groups than in twos. Food is better when cooked by others, and coffee far tastier when brewed for a penny.

In this sealed universe of turn-of-the-century cafés, the décor is invariably the same: grandfather clock, ringing cash registers, the tipping dish left scrupulously half emptied by absentee bathroom attendants, the busy chatter of *flippers* (as pinball machines are called) and the rush of waiters fanning out coasters from white aprons with the breezy dexterity of seasoned magicians.

CAFÉ, LACOSTE

Cafés, bars, and awnings: a cross between burgundy and faded crimson—the colors of bold and boisterous evenings in France.

BAR DES AMIS, BEAUJOLAIS

*One says, "Meet you Chez Josette,"
or at "La Nicoise," sometimes
before asking whether it's all right
to meet at all. The assumption
that people like people underscores
everything.*

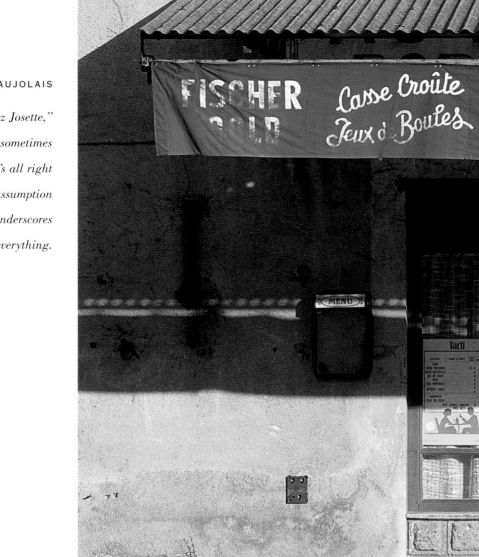

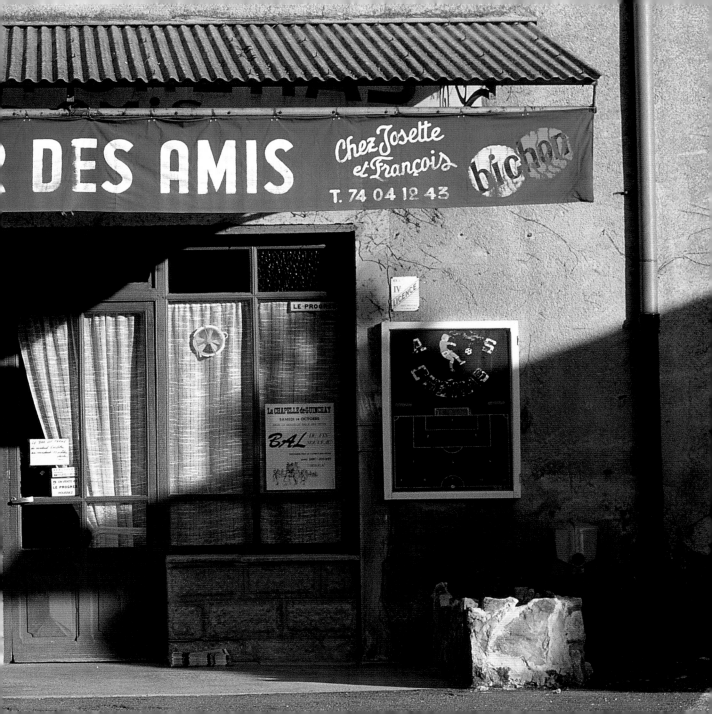

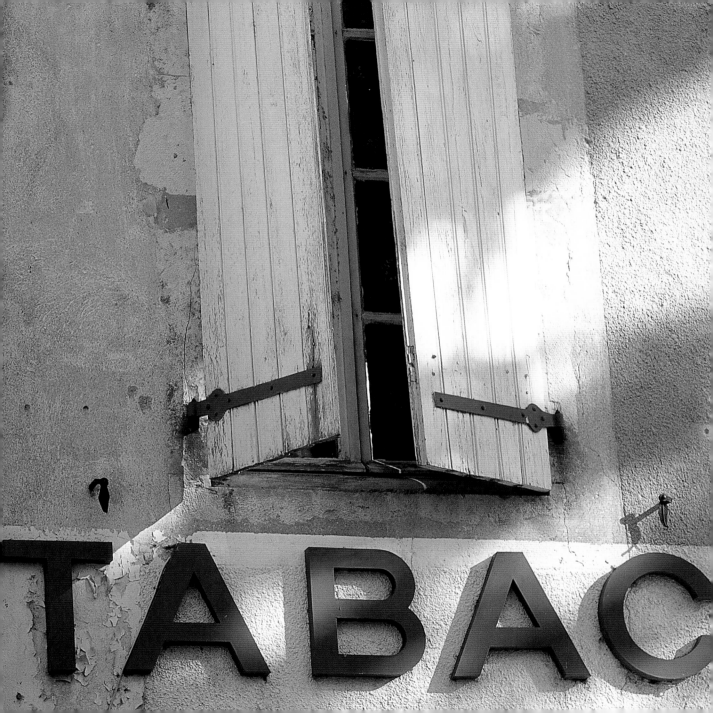

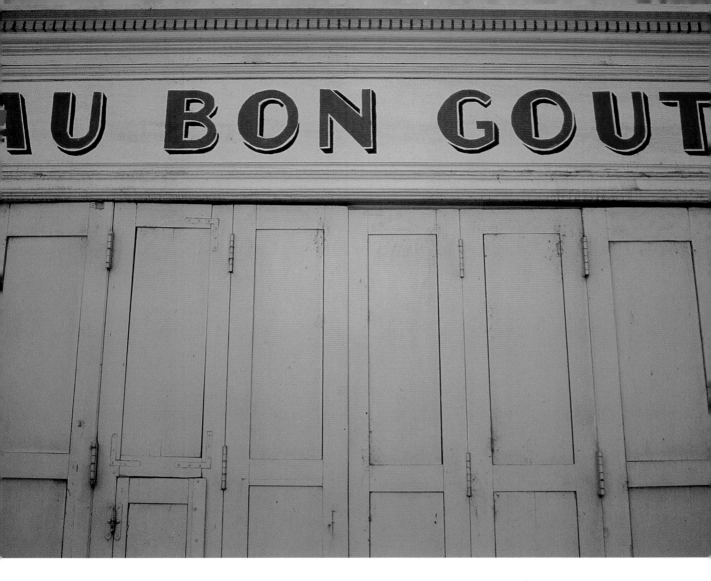

CAFÉ, BORDEAUX

TABAC, BORDEAUX

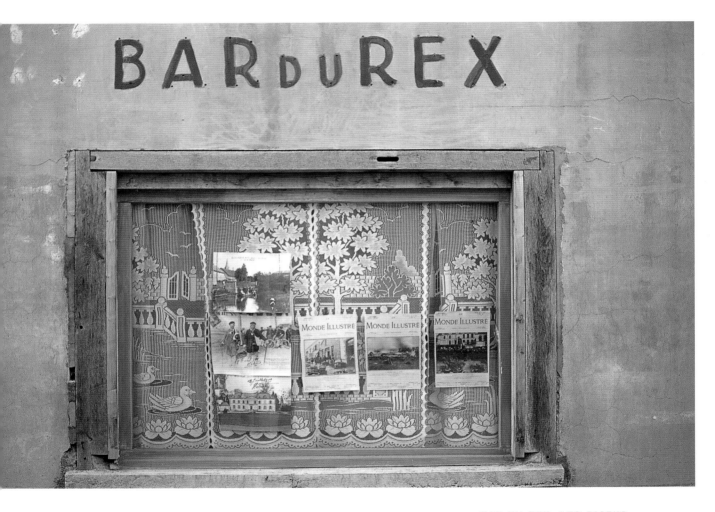

BAR DU REX, LES RICEYS

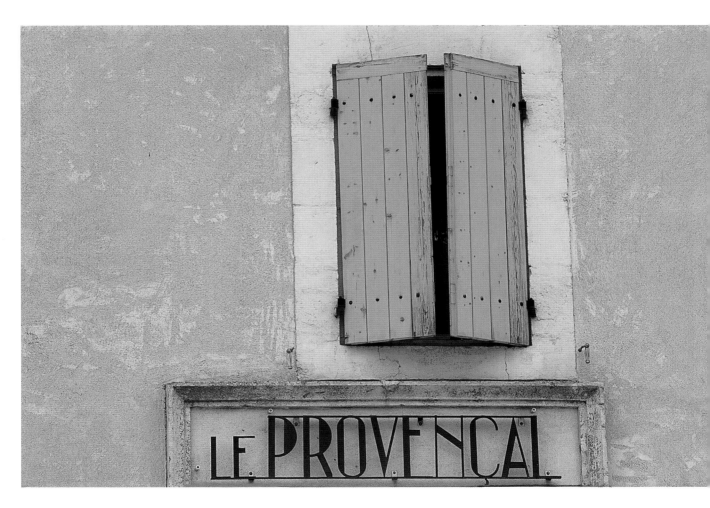

LE PROVENÇAL, GORDES

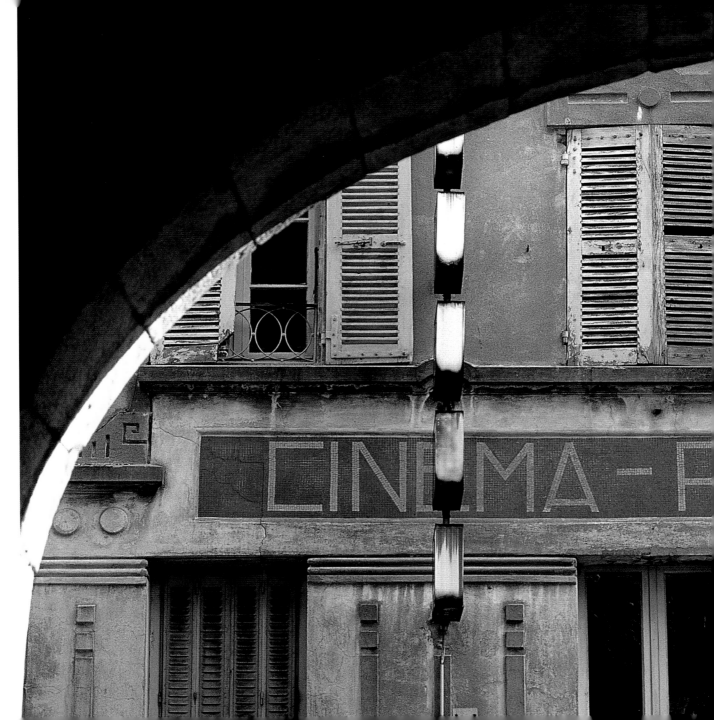

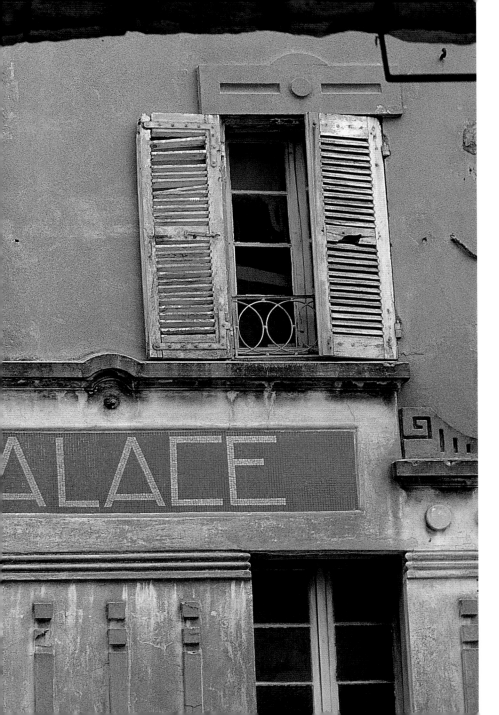

CINÉMA PALACE

Lost somewhere in back alleys, seedy movie houses are always called "Palace" in Europe. On Sunday families throng there; on weekdays, they're home to couples who've nowhere to go, to those who play hooky, and to the lonely who seek out the lonely.

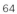

HÔTEL DE LA POSTE,
ST.-MARTIN

Persiennes: *what's behind them
when they're shut? What decade is
it inside that room? Who sleeps
in there, what sort of people, what
do they do, eat, read, when the
shutters are fully drawn?*

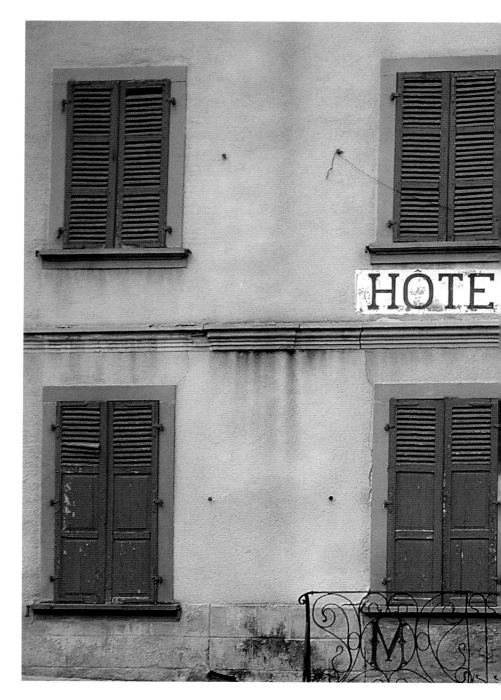

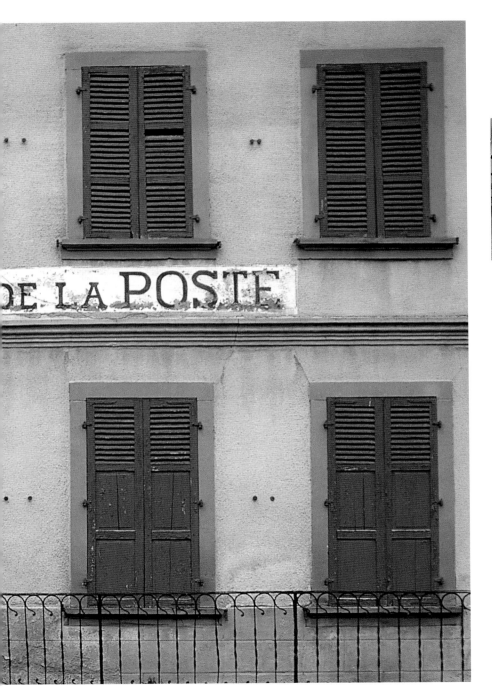

HÔTEL, PERPIGNAN

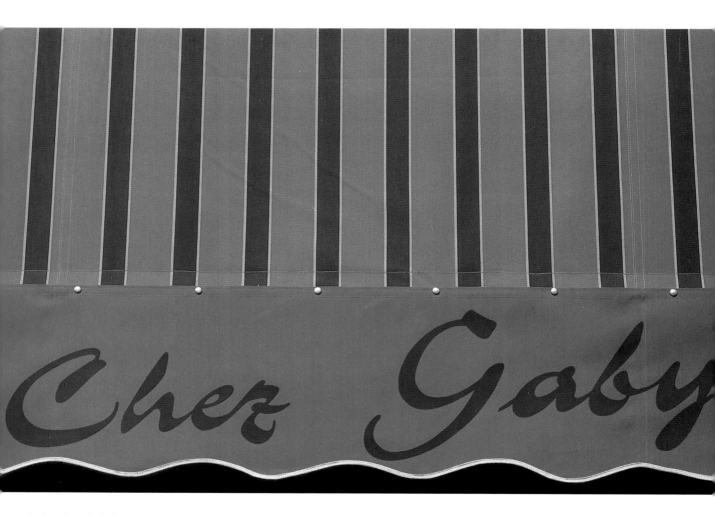

CHEZ GABY, RIANS

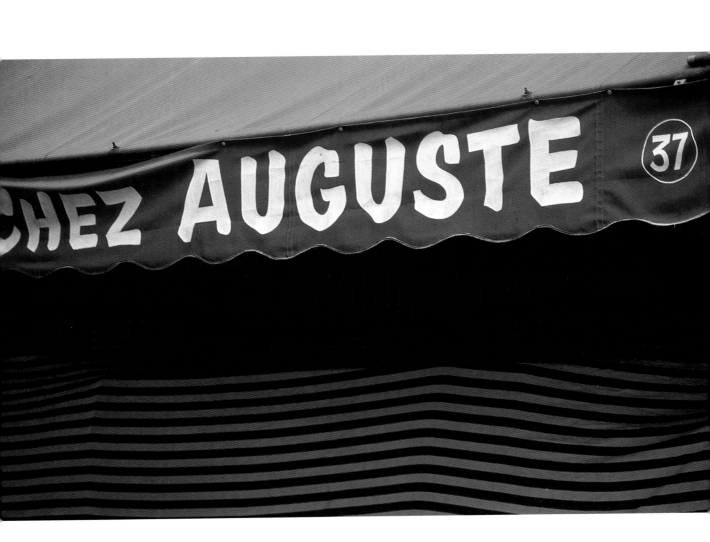

CHEZ AUGUSTE, NICE

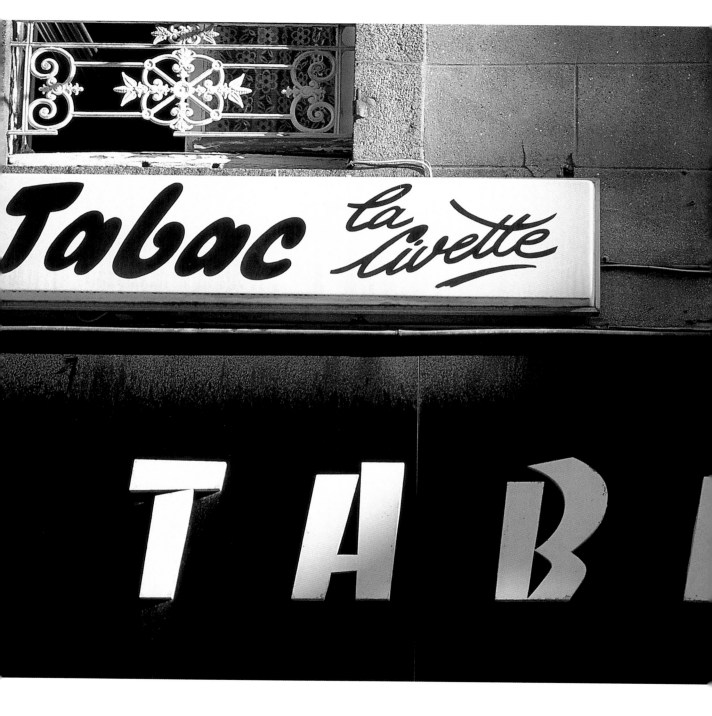

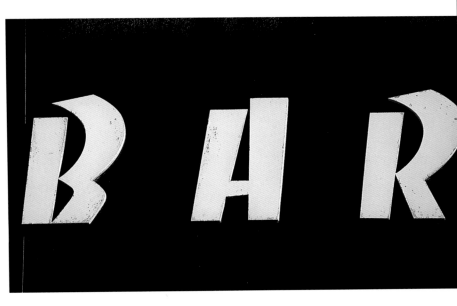

BAR, GRANVILLE

TABAC, GRANVILLE

*The air is laden with the scent
of Gauloises and Gitanes, with
the allure of friendships that
can easily turn a verbal tussle
into a lifelong passion, because
passions need tussling, and
friendships are lifelong passions.*

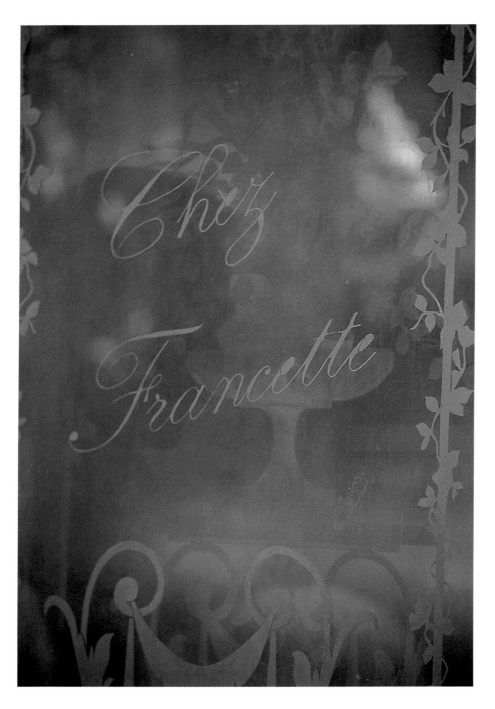

CHEZ FRANCETTE, UZÈS

Everyone always welcomes everyone else—but there is a pause, a moment of hesitation, and no matter how you get used to a place, there'll always come that telltale jolt in your heart when you walk in.

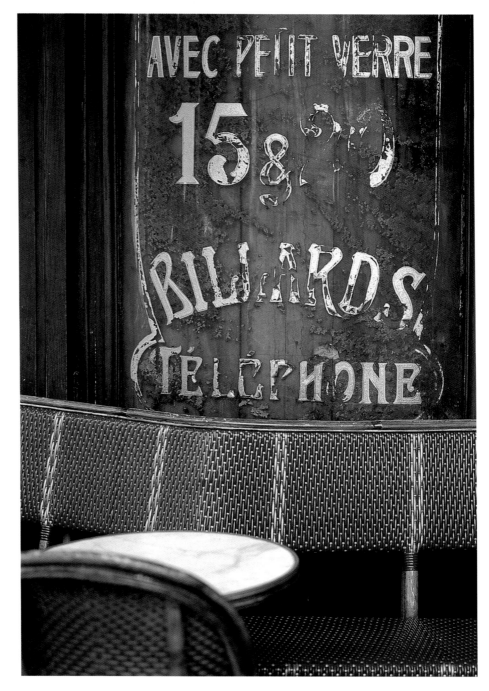

CAFÉ, PARIS

Opening the door and hearing the
click followed by the rattle of the
glass panel shaking in its frame,
and, spotting someone's face, you
suddenly realize you've come home.

AUBERGE, SARLAT

The tavern—closed in the afternoon, or closed for the day, or permanently closed? A landmark, a relic, or is this business as usual?

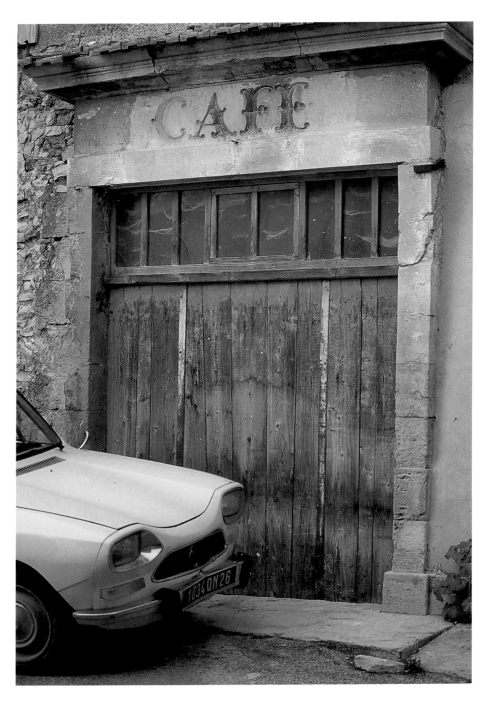

CAFÉ, ROUSSET-LES-VIGNES

TOUT VA BIEN, NÎMES

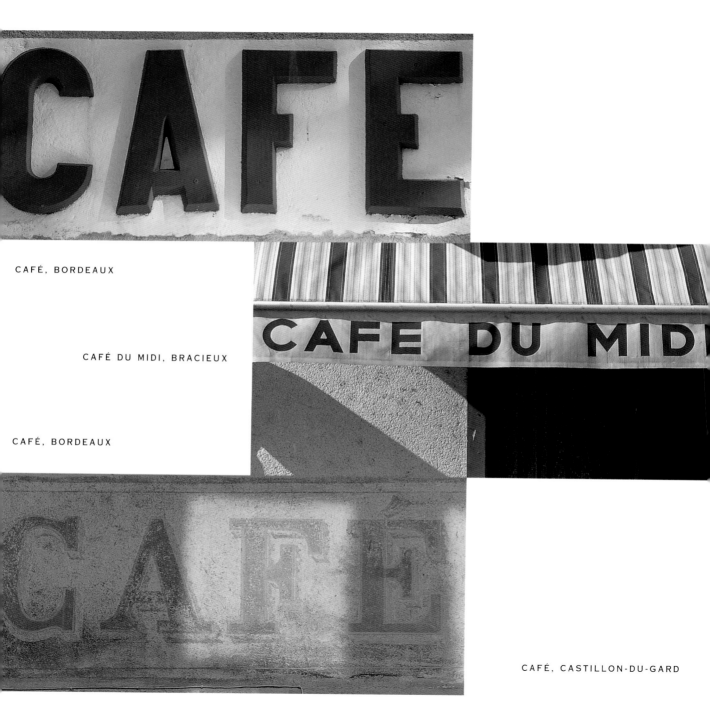

CAFÉ, BORDEAUX

CAFÉ DU MIDI, BRACIEUX

CAFÉ, BORDEAUX

CAFÉ, CASTILLON-DU-GARD

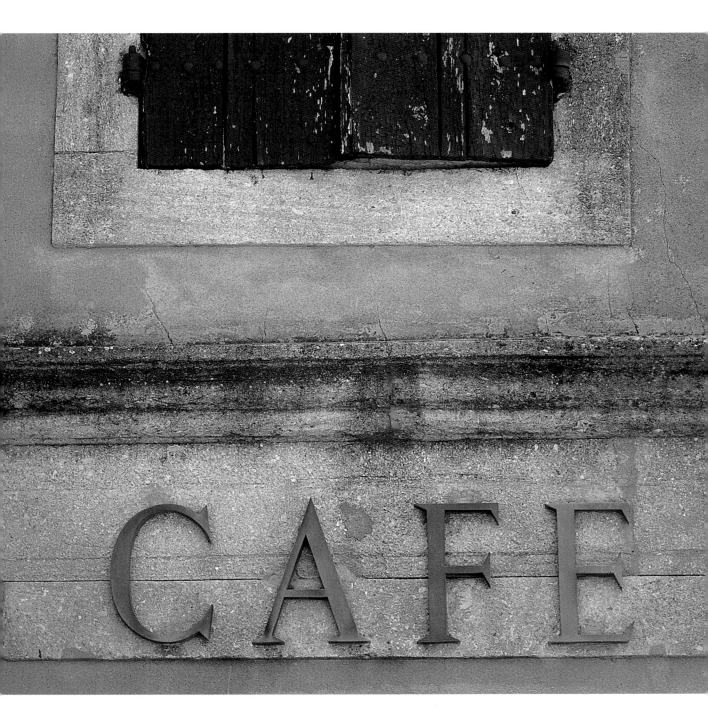

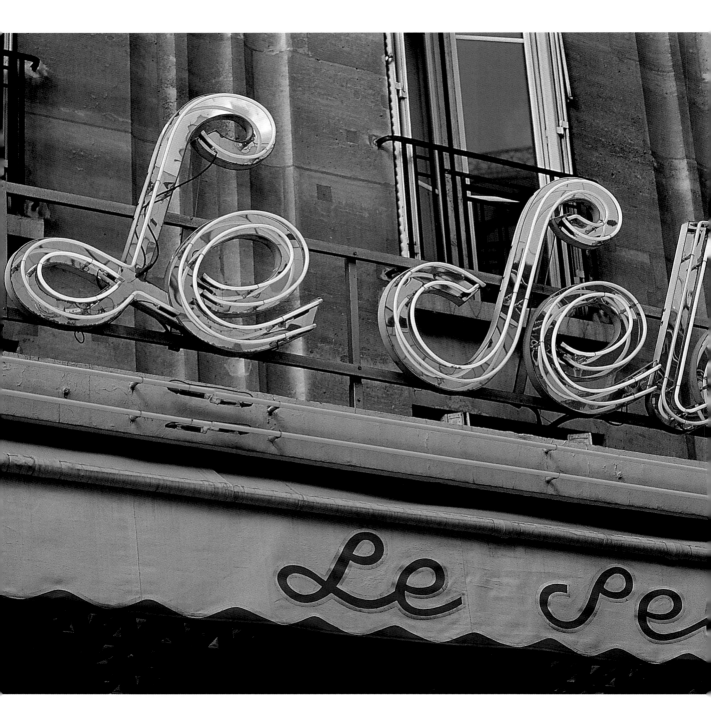

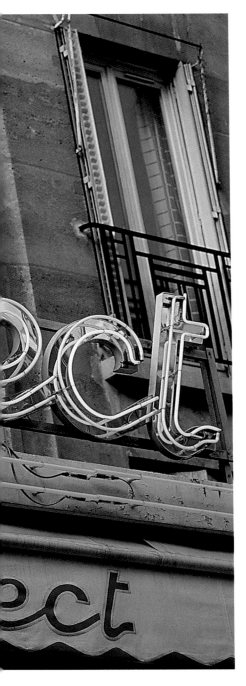

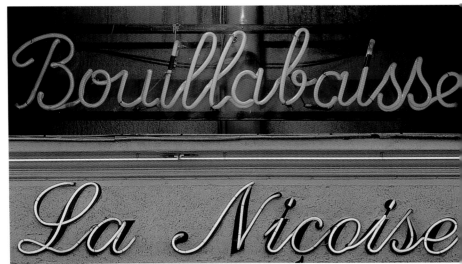

BOUILLABAISSE, MARSEILLE

LA NIÇOISE, NICE

"Bouillabaisse" *and* "La Niçoise"
*bear the stamp not of a young girl's
handwriting, but of her grown-up
teacher who's forgotten how to write
anywhere but on blackboards.*

UBO RIPOLIN, RENNES

overleaf

LE SELECT, PARIS

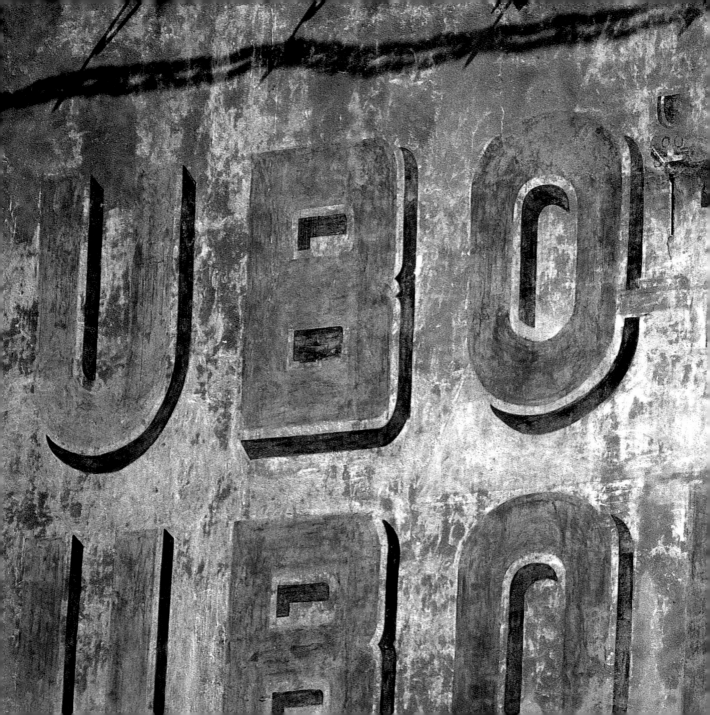

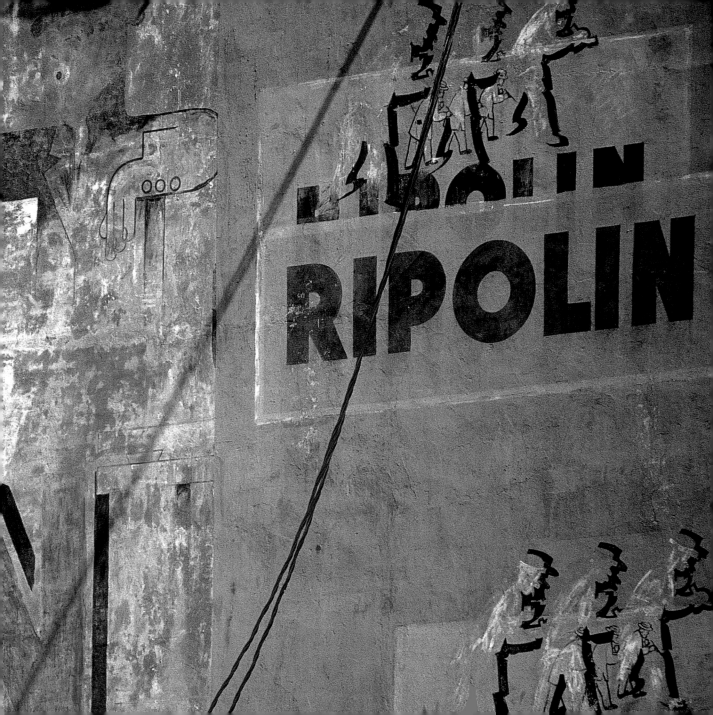

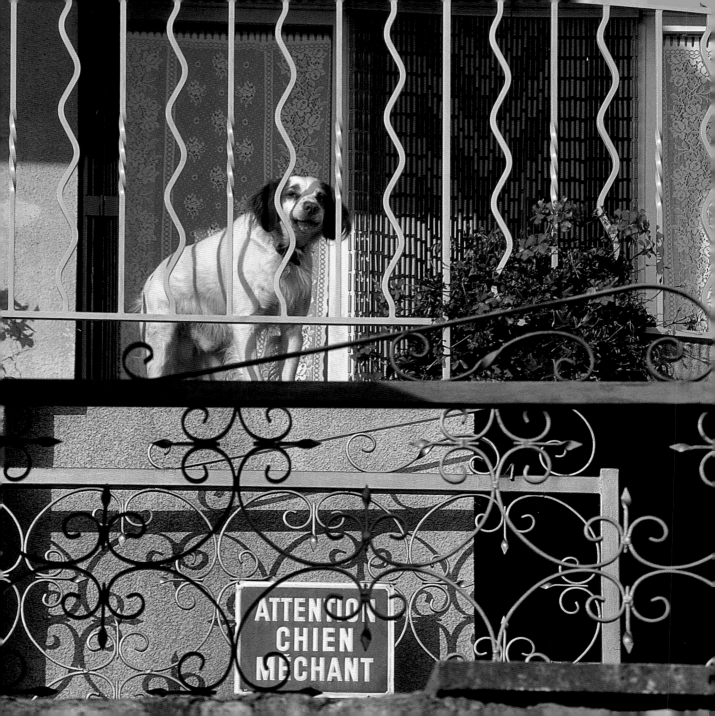

ATTENTION
CHIEN
MÉCHANT

CHIEN MÉCHANT,
ROUSSET-LES-VIGNES

*"Beware: Bad Dog" is what the
sign says. Is it fibbing and just
meant to scare you? Is French
direct and brutal (bad dog, don't
mess with us) or is it considered,
roundabout (just pretend
you're scared)? The dog is no
more harmful than Tintin's
dog, Snowy.*

Fussy, mannered, ever-attentive France. A caveat for each occasion. Do not post. Do not enter. Beware of dog. Friendly tips, friendly reminders. Entrance free. *Entrez!* This way to the Turn right for the But do not spit, do not smoke, do not urinate. Signs are made forever. Signs are written in heaven. The French listen. They do as they're told, they file in when asked. France has invented the word for it: *"queue."* People queue up everywhere, they like lines, trust lines. Which is why perhaps they worship not so much their laws, but their regulations. Laws, when no one's looking, you may break; regulations are a matter of conscience. With time, however, these too must pale, and all empires of signs eventually come under attack. The French perfected the study of signs; they called it *sémiotique.* It's never what the sign says that matters. Nor is it what it never says, or cannot say. Nor, for that matter, is it what a sign says to me and only me. What matters is the life of signs, signs over time, or how the age of each sign has become a sign as well, pointing to a time when the French, like everyone else during the lilac-gilded days of prewar, fin-de-siècle Europe, still thought that signs couldn't tell a lie.

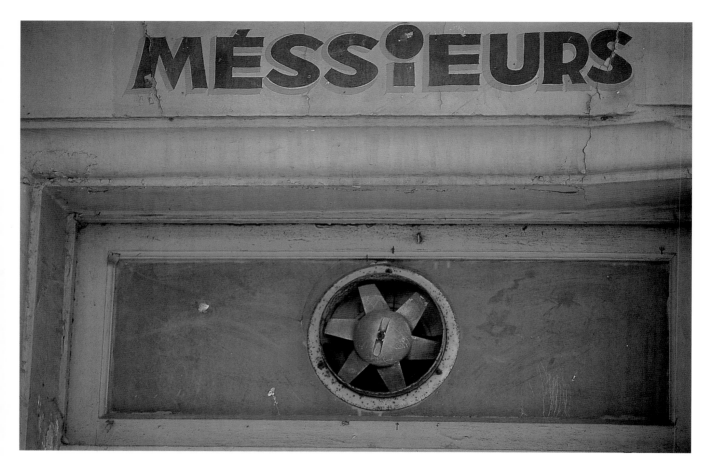

MESSIEURS, ISLE-SUR-LA-SORGUE

DÉFENSE D'URINER, AUXERRE

A passion for signs. France has the greatest number of designated spots where the body can relieve itself. It is up front about all the body's needs: restaurants, cafés, benches, bars, bathrooms. Always polished in its choice of words. Vespassienne—after Roman emperor Vespassian, who established its use—means "public urinal."

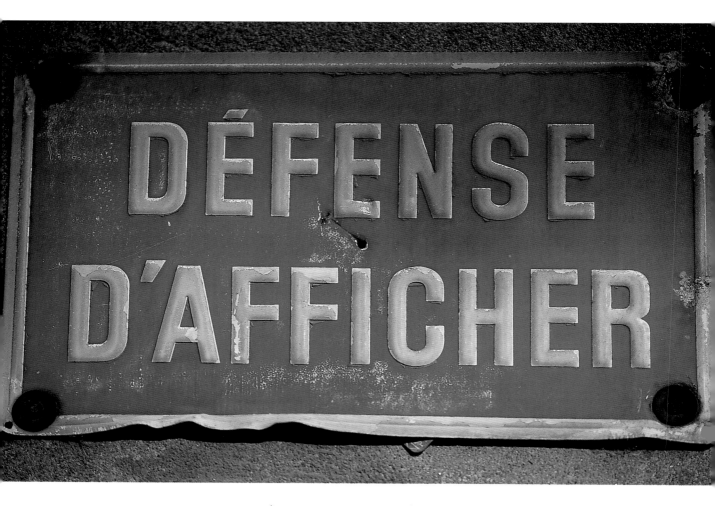

DÉFENSE D'AFFICHER, UZÈS

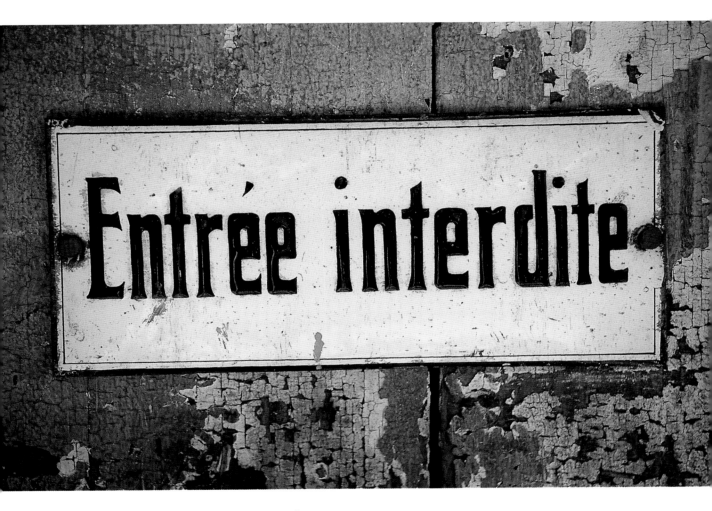

ENTRÉE INTERDITE, COTIGNAC

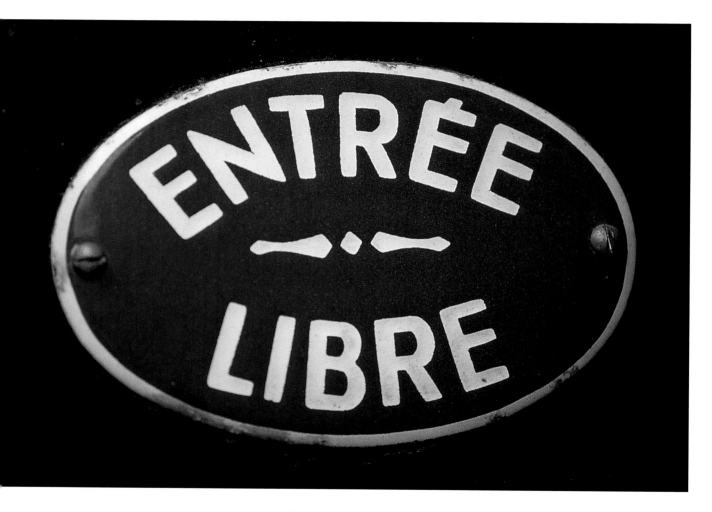

ENTRÉE LIBRE

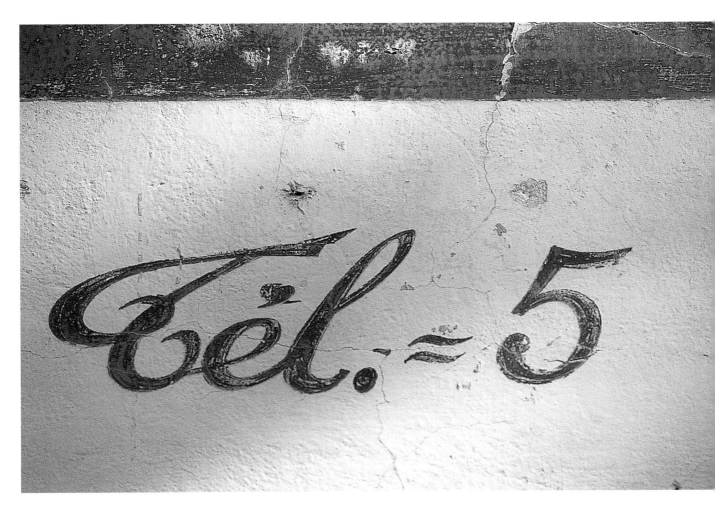

TEL. 5, BORDEAUX

The telephone number is 5. Short enough to be plain—or just cryptic?

90

AVIS, LYON

Something so irreducibly scrupulous and fastidious, so neat, so tidy, so well-groomed, in the way the French show they care about details and small things, down to the unbending directive that patrons must check their umbrellas—for 50 centimes!

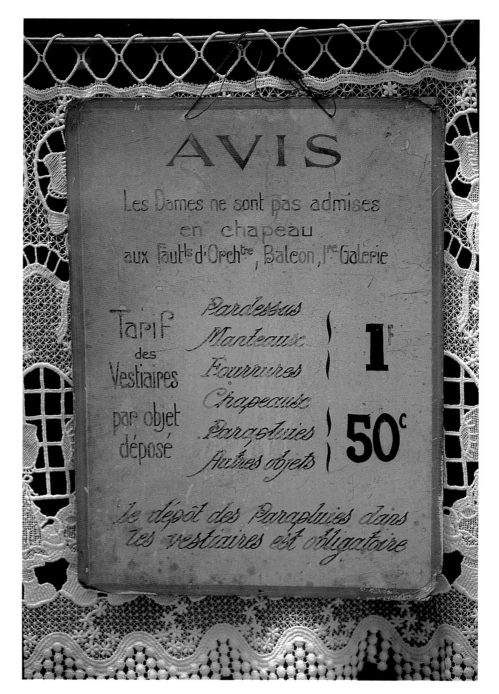

Alimentation: *Food shop*

Arrondissement: *District, area*

Auberge: *Inn, tavern*

Avis: *Notice*

Beurre: *Butter*

Bonneterie: *Hosiery*

Boucherie: *Butcher's shop*

Boudins frais: *Cold sausages*

Bouillabaisse: *Fish stew*

Boulangerie: *Bakery*

Chapeau: *Hat*

Chapellerie: *Hat shop*

Charcuterie: *Pork-butcher's shop*

Chaudronnier: *Coppersmith, ironmonger*

Chaussure: *Footwear*

Chemiserie: *Shirt shop*

Cheval: *Horse*

Chevreuil: *Venison*

Coing: *Quince*

Confection: *Clothing*

Cordonnerie: *Shoemaker's shop*

Crémerie: *Dairy*

Défense d'afficher: *No posting*

Droguerie: *Chemist's shop*

Entrée interdite: *No entrance*

Entrée libre: *Free entrance*

Entrez sans frapper: *Enter without knocking*

Épicerie: *Grocer's shop*

Étude: *Office*

Fermier: *Farmer*

Figue: *Fig*

Fourrure: *Fur*

Fromagerie: *Cheese shop*

Fruitier: *Fruit shop*

Gibier: *Game*

Groseille: *Red currant*

Herboristerie: *Herbalist's shop*

Imperméable: *Raincoat*

Jouet: *Toy*

Légume: *Vegetable*

Livre: *Book*

Manteau: *Coat*

Marchand: *Shopkeeper*

Mercerie: *Haberdashery, notions shop*

Mirabelle: *Cherry plum*

Mode: *Fashion*

Nouveautés: *Fancy goods, linen-drapery*

Oeufs: *Eggs*

Papeterie: *Stationery shop*

Parapluies: *Umbrellas*

Pardessus: *Overcoat*

Persiennes: *Shutters*

Phytologiste: *Herbalist*

Plage: *Beach*

Poisson: *Fish*

Produit: *Produce*

Quincaillerie: *Hardware shop*

Sous peine d'amende: *Punishable by fine*

Tabac: *Tobacco*

Tissus: *Fabrics, textiles*

Tout va bien: *All is well*

Traiteur: *Caterer*

Vestiaire: *Cloakroom*

Vie quotidienne: *Everyday life*

Vin: *Wine*

Volaille: *Poultry*

ACKNOWLEDGMENTS

The precision of the team that helped to create this book would make any obsessive person happy—especially this photographer. I am grateful to Peter Workman, Ann Bramson, Paul Hanson, Ann Treistman, Elizabeth Johnsboen, Nancy Murray, LeAnna Weller Smith, Dania Davey, and *bien sûr*, André Aciman.

—*Steven Rothfeld*

BIOGRAPHIES

STEVEN ROTHFELD has illustrated works by Gerald Asher, Frances Mayes, Wolfgang Puck, Nancy Silverton, Patricia Wells, and many others. His own books include *French Dreams*, which won the Communications Arts Award for Excellence for books of photography, as well as *Italian Dreams* and *Irish Dreams*.

ANDRÉ ACIMAN is the author of the acclaimed memoir *Out of Egypt* and of *False Papers: Essays on Exile and Memory*. A frequent contributor to *The New Yorker*, *The New Republic*, *The New York Review of Books*, and *The New York Times*, he teaches at Bard College and is a fellow at the New York Public Library's Center for Scholars and Writers.